One Hungry Monster

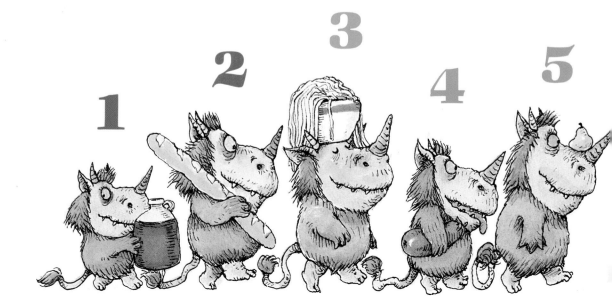

One Hungry Monster

A Counting Book in Rhyme

by Susan Heyboer O'Keefe
illustrated by Lynn Munsinger

Little, Brown and Company
Boston New York Toronto London

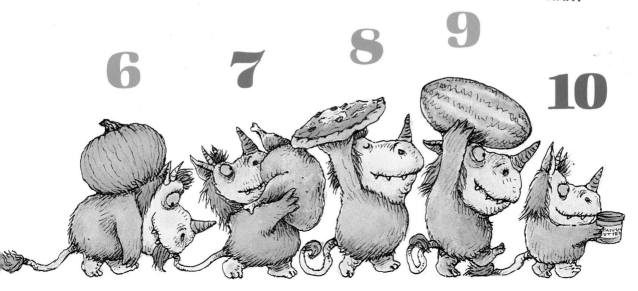

6 7 8 9 10

For Ronni, with thanks
— S.H.O'K.

For John, Chris, Mary, and Peter
— L.M.

Text copyright © 1989 by Susan Heyboer O'Keefe
Illustrations copyright © 1989 by Lynn Munsinger

First Paperback Edition

Library of Congress Cataloging-in-Publication Data
O'Keefe, Susan Heyboer.
 One hungry monster.
 Summary: Insatiable monsters demanding
food increase in number from one to ten until a small
boy finally orders them all out of his bedroom.
 ISBN 0-316-63385-2 (hc)
 ISBN 0-316-63388-7 (pb)
 [1. Monsters — Fiction. 2. Stories in rhyme.
 3. Counting] I. Munsinger, Lynn, ill.
 II. Title. PZ8.3.0370n 1989 [E] 88-8093

10 9 8 7 6 5 4 3
WOR
Published simultaneously in Canada
by Little, Brown & Company (Canada) Limited
Printed in the United States of America

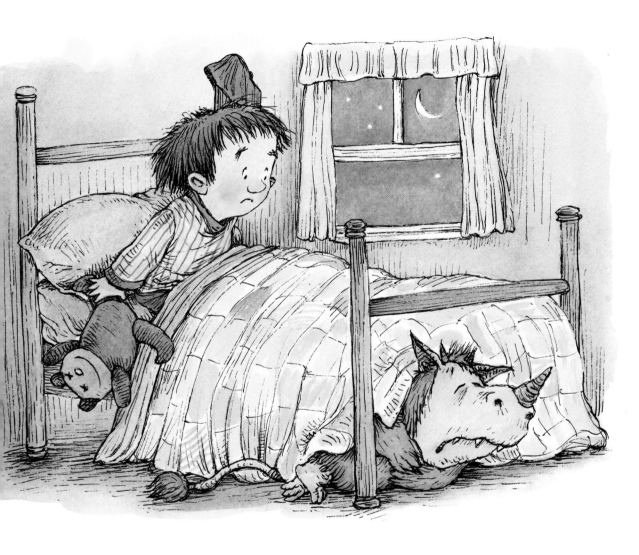

One hungry monster
underneath my bed,
moaning and groaning
and begging to be fed.

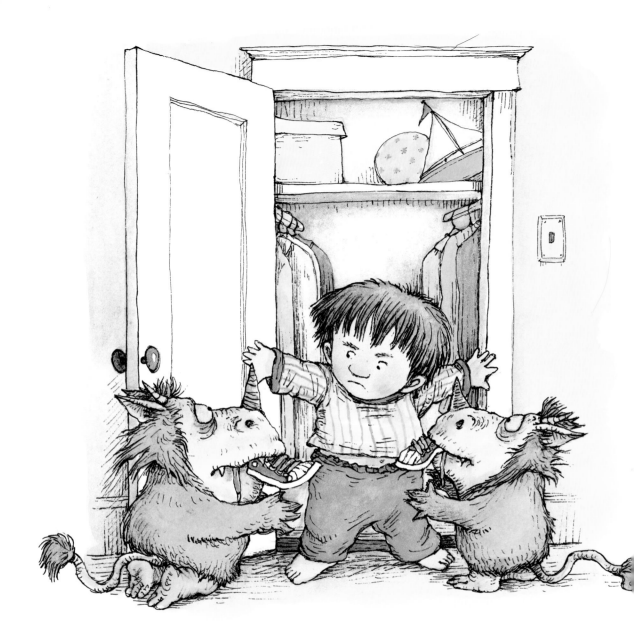

Two hungry monsters
at my closet door,
chewing up my sneakers,
asking me for more.

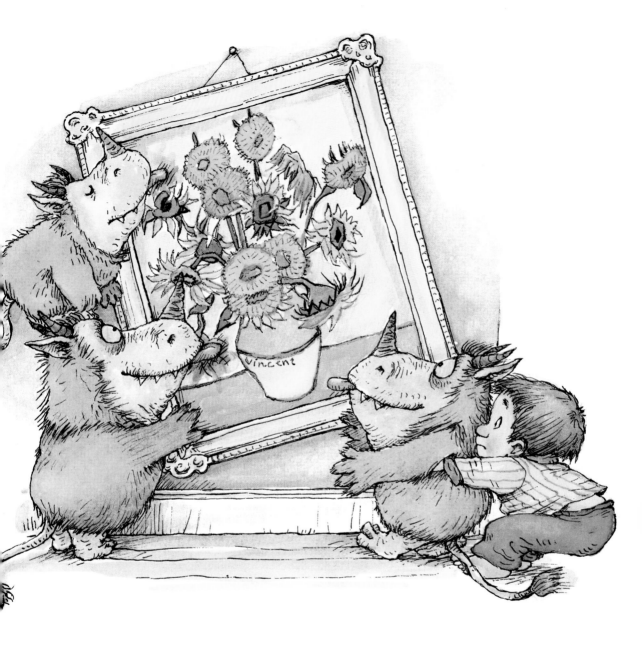

Three hungry monsters
in the upstairs hall,
lick the flower painting
hanging on the wall.

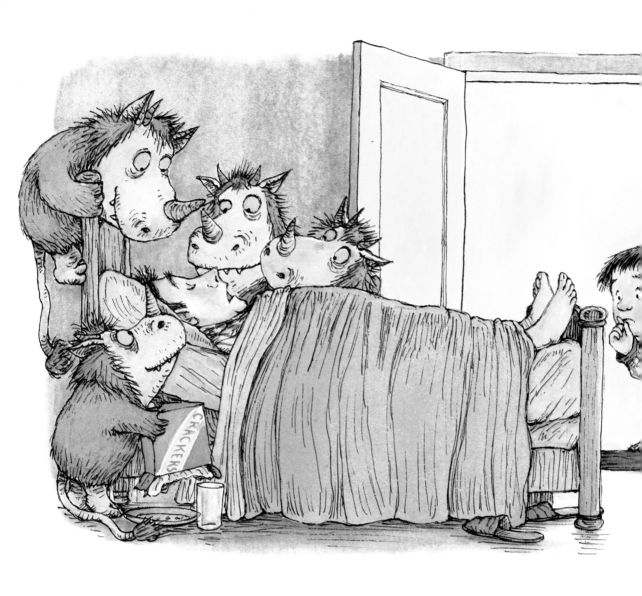

Four hungry monsters
'round my Daddy's head,
sniffing out the crackers
he'd eaten in his bed.

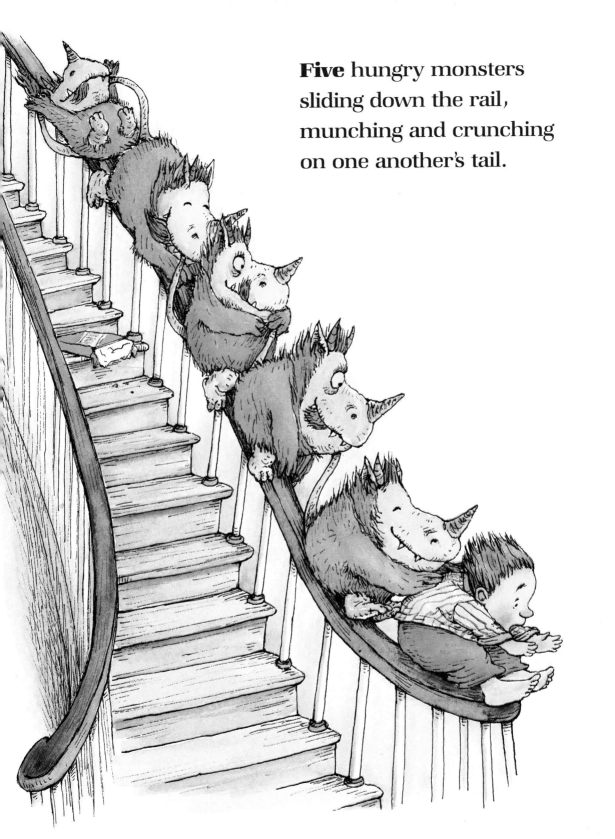

Five hungry monsters
sliding down the rail,
munching and crunching
on one another's tail.

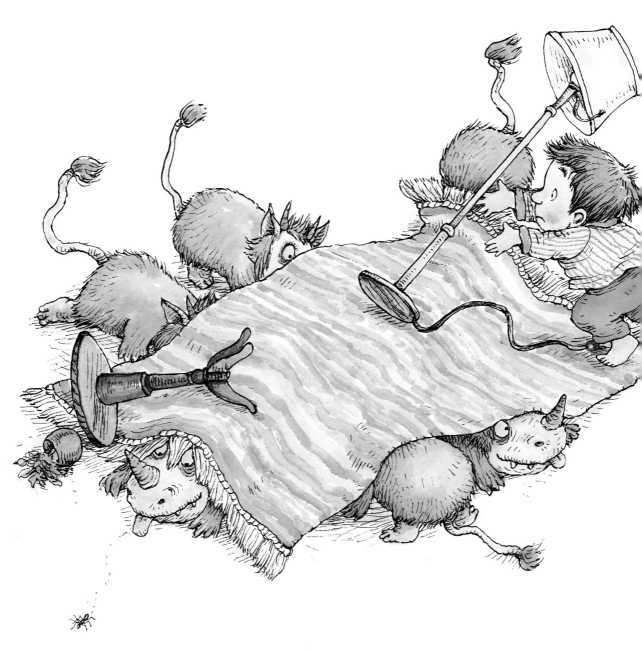

Six hungry monsters
underneath the rug,
tracking down some footprints
to catch a tasty bug.

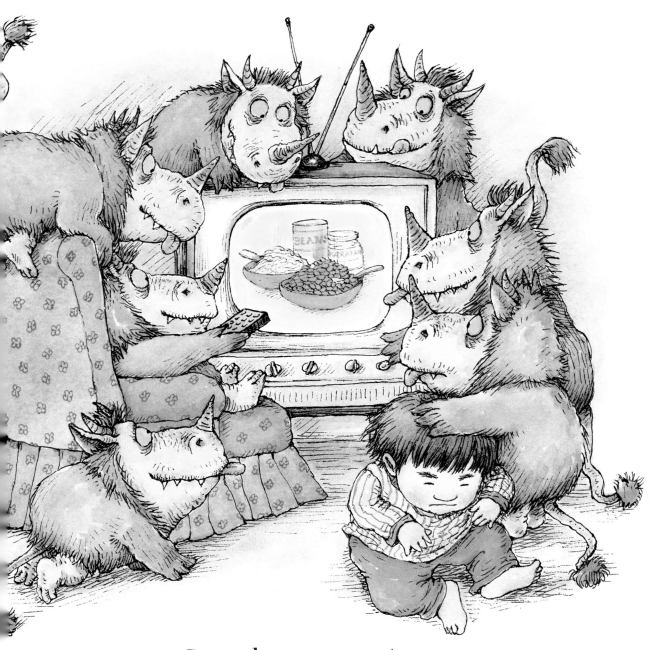

Seven hungry monsters
'round our TV screen,
drooling at commercials
for sauerkraut and beans.

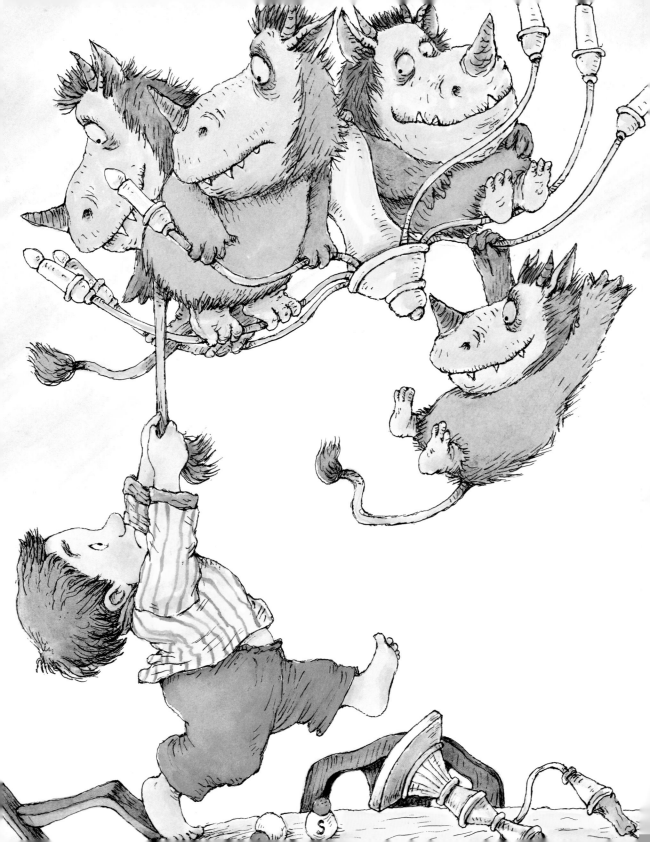

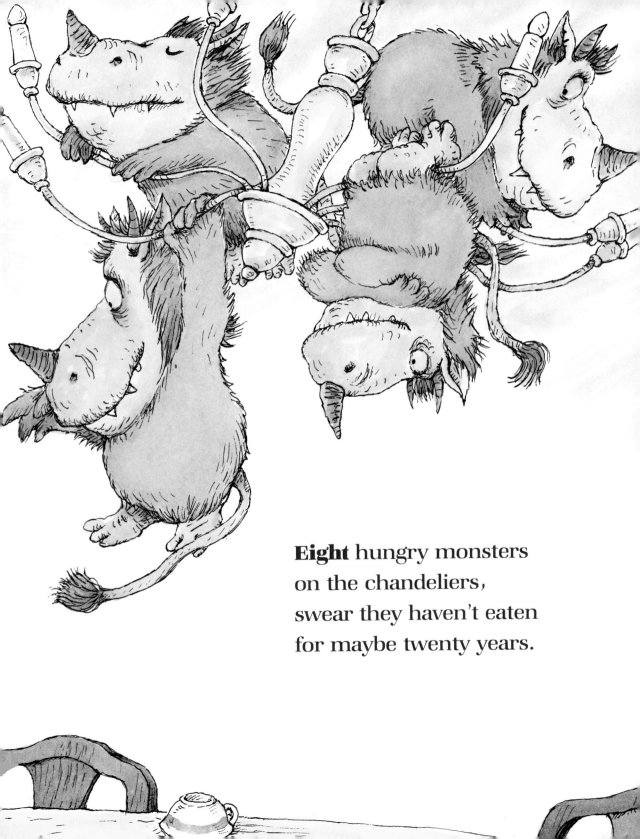

Eight hungry monsters
on the chandeliers,
swear they haven't eaten
for maybe twenty years.

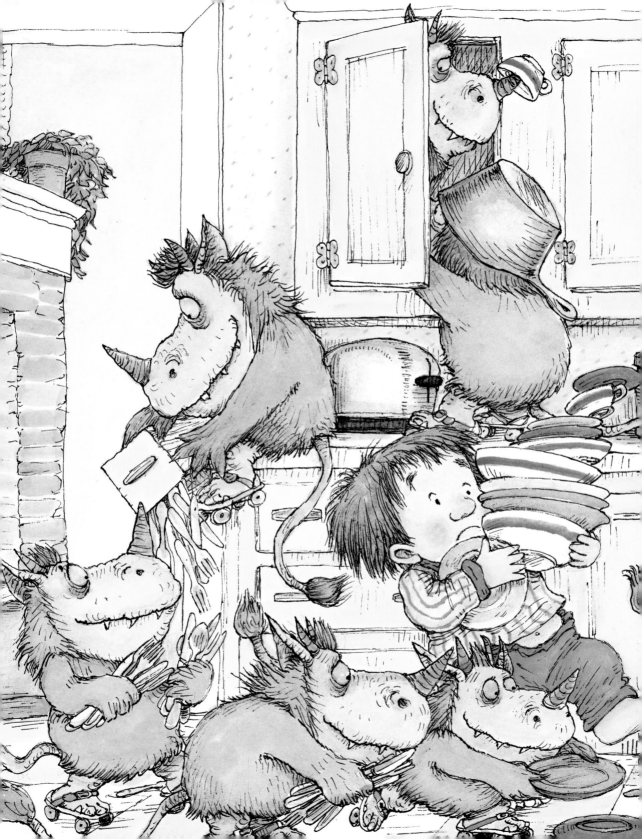

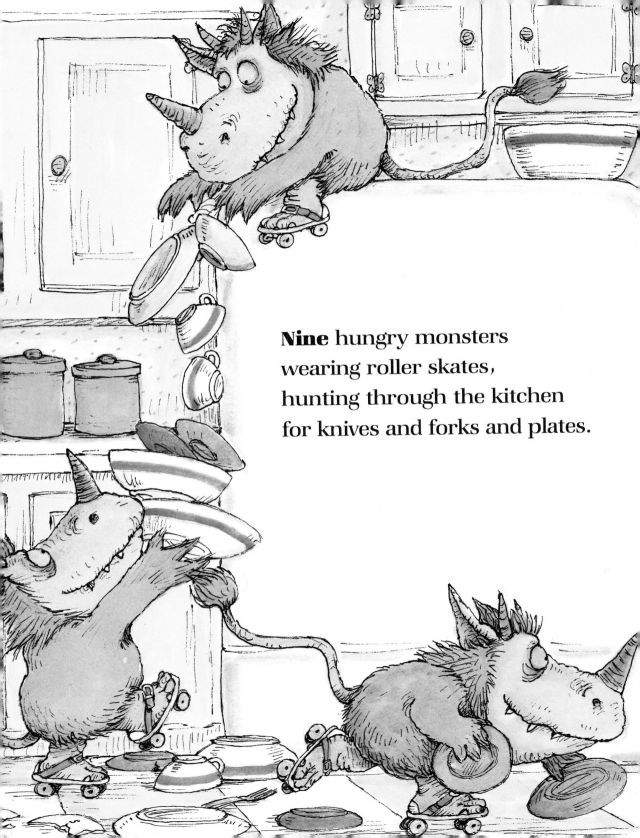

Nine hungry monsters
wearing roller skates,
hunting through the kitchen
for knives and forks and plates.

Ten hungry monsters,
about to fuss and kick,

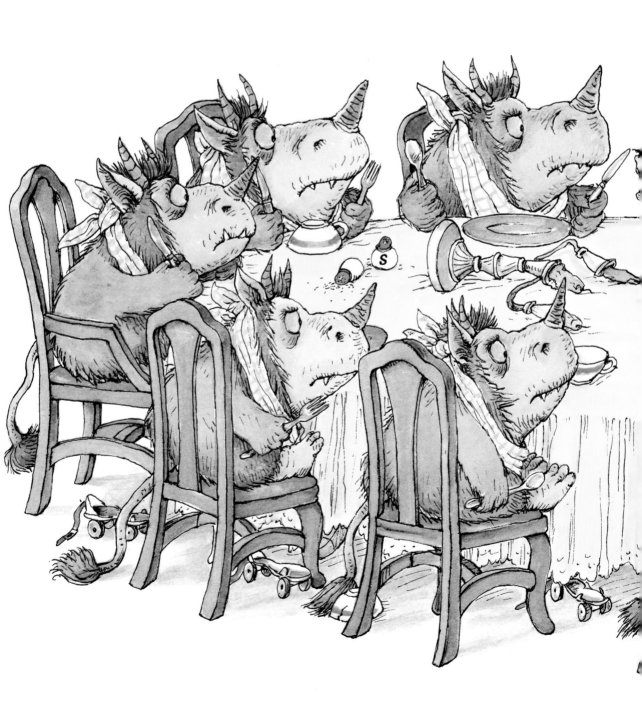

won't get out, they tell me,
unless I feed them quick!

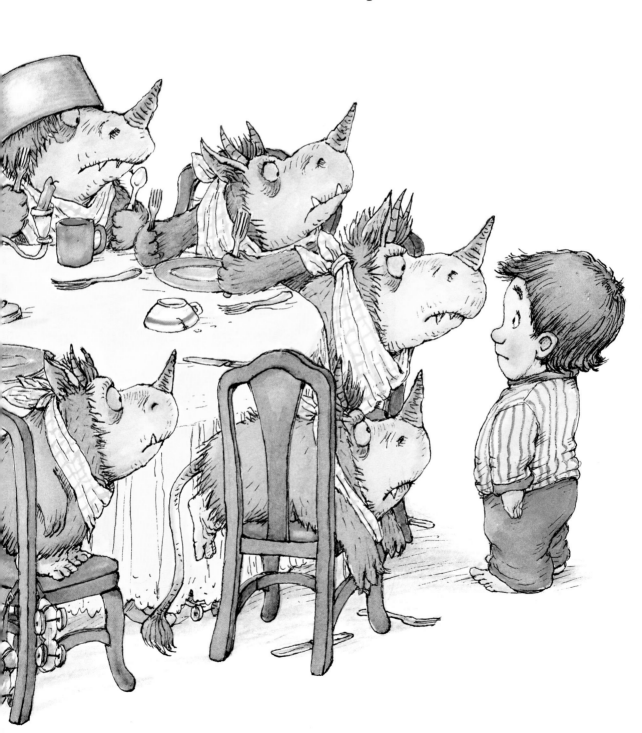

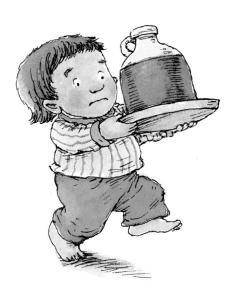

So I bring out **1** jug of apple juice,

2 loaves
of bread,

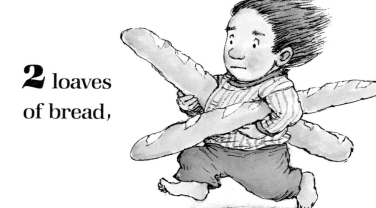

3 bowls of spaghetti
that they dump upon my head,

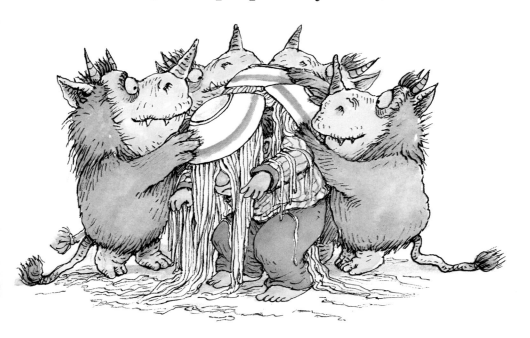

4 purple eggplants,

5 pickled pears,

6 orange pumpkins
they climb up and down
like stairs,

7 roasted turkeys,

8 pizza pies,

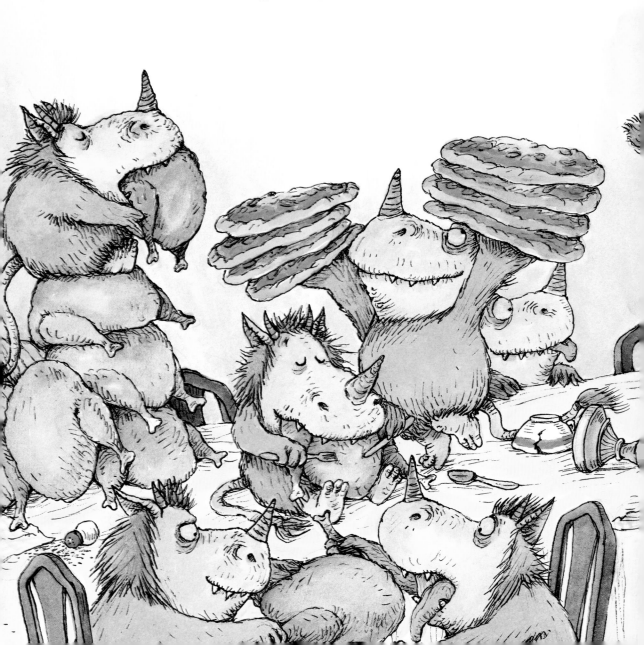

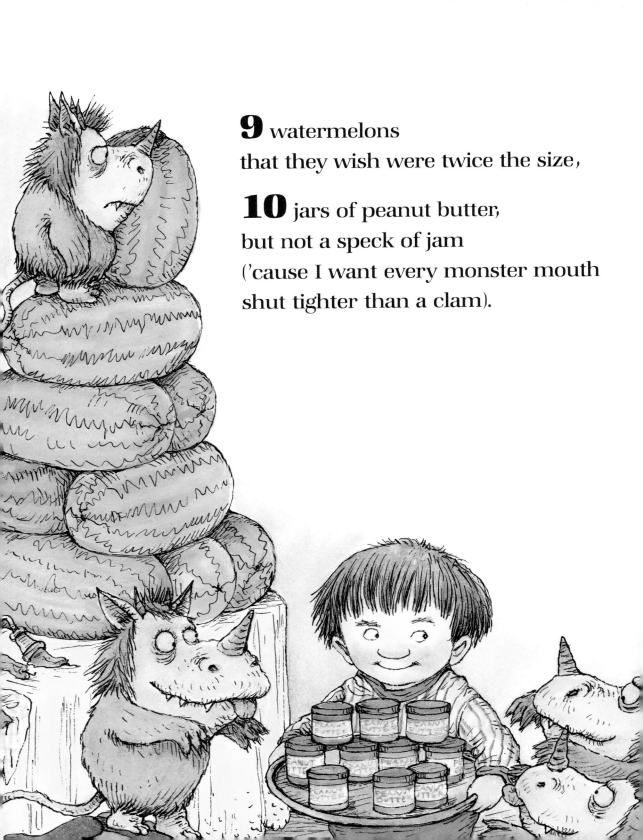

9 watermelons
that they wish were twice the size,

10 jars of peanut butter,
but not a speck of jam
('cause I want every monster mouth
shut tighter than a clam).

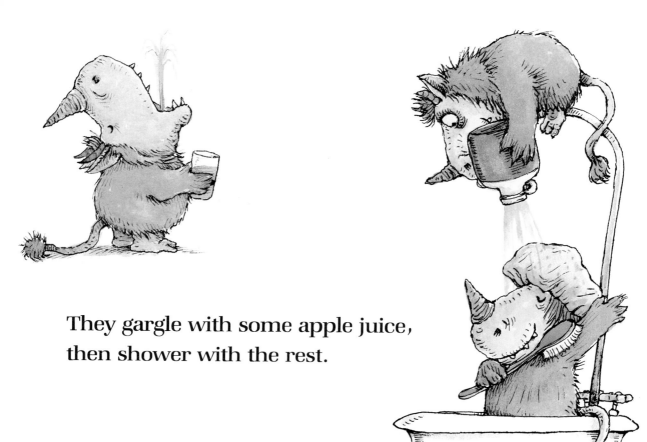

They gargle with some apple juice,
then shower with the rest.

They pinch the bread to bread crumbs
and won't clean up their mess.

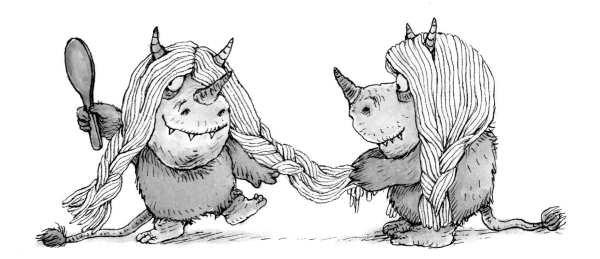

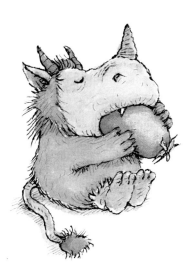

They braid spaghetti into wigs
and eat the eggplants whole,
and learn that pickled pears
won't bounce —
and neither will they roll.

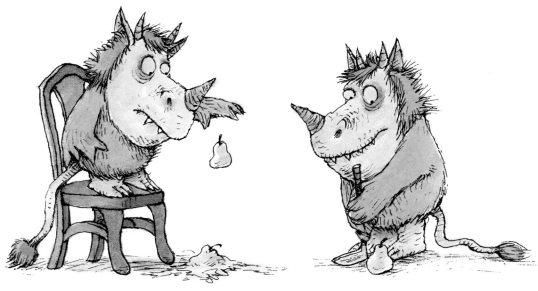

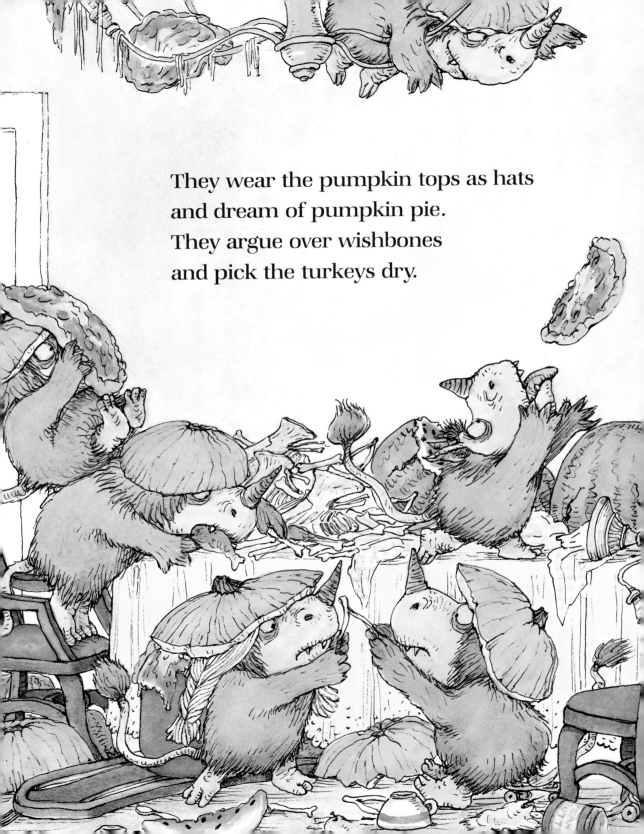

They wear the pumpkin tops as hats
and dream of pumpkin pie.
They argue over wishbones
and pick the turkeys dry.

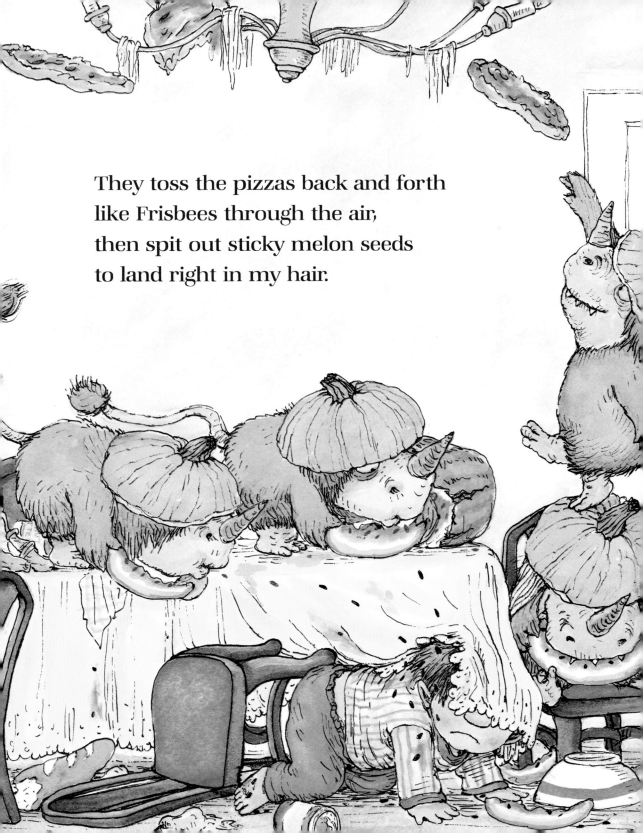

They toss the pizzas back and forth
like Frisbees through the air,
then spit out sticky melon seeds
to land right in my hair.

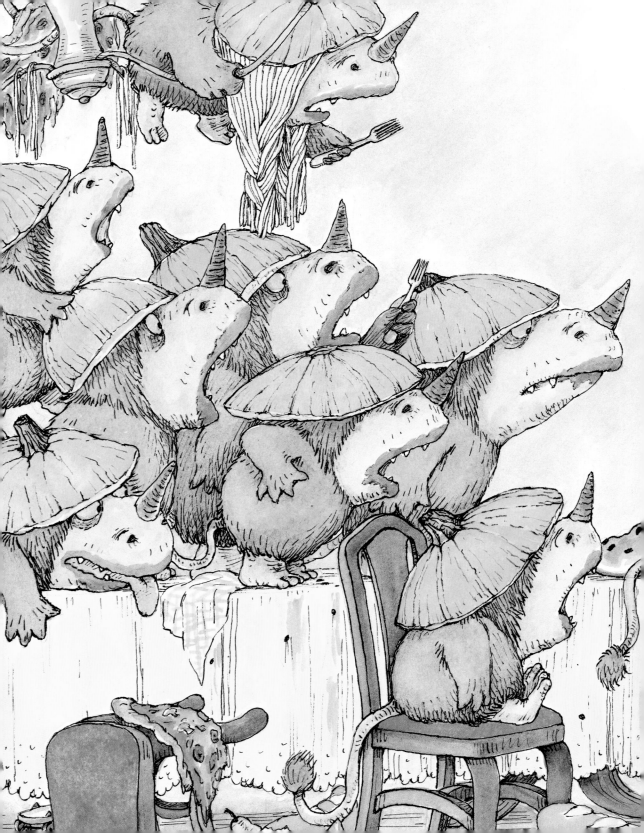

They paint the peanut butter
like lipstick on their mouths,
then stamp their feet and boldly say,
"What ELSE is in this house?"

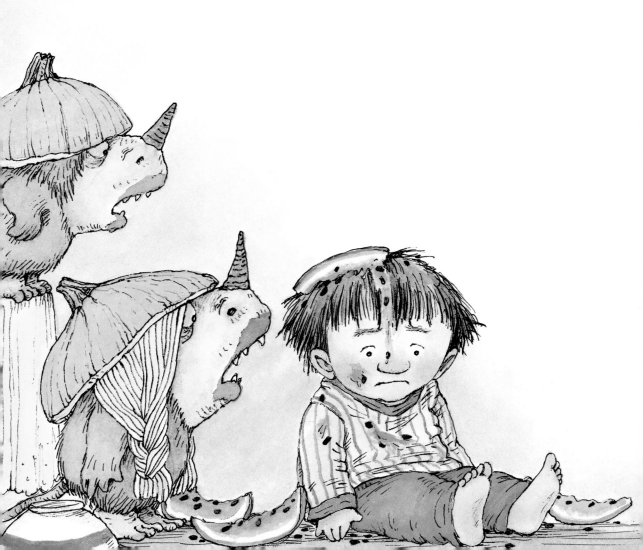

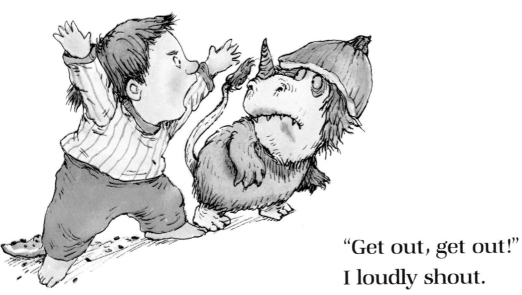

"Get out, get out!"
I loudly shout.
"You've made a mess
and then, no less,
you ate my food,
and were quite rude.
You put me in
a nasty mood.
You are so bad
it makes me mad!

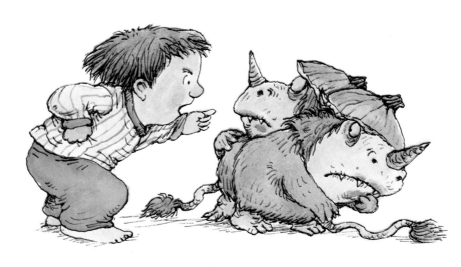

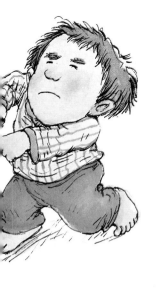

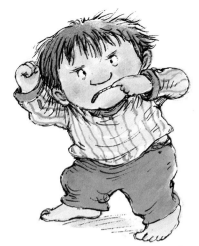

"It makes me want
to squirm and twist,
to make a face,
and shake my fist,
to stamp the floor
and kick the door,
and then to do it
all once more!
And so without
a single doubt,
I tell you now —
get out, get out!"

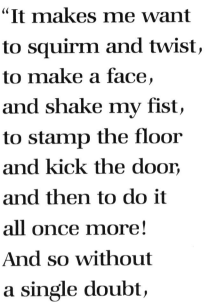

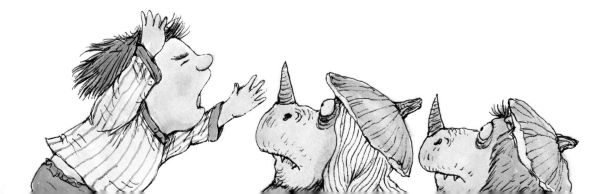

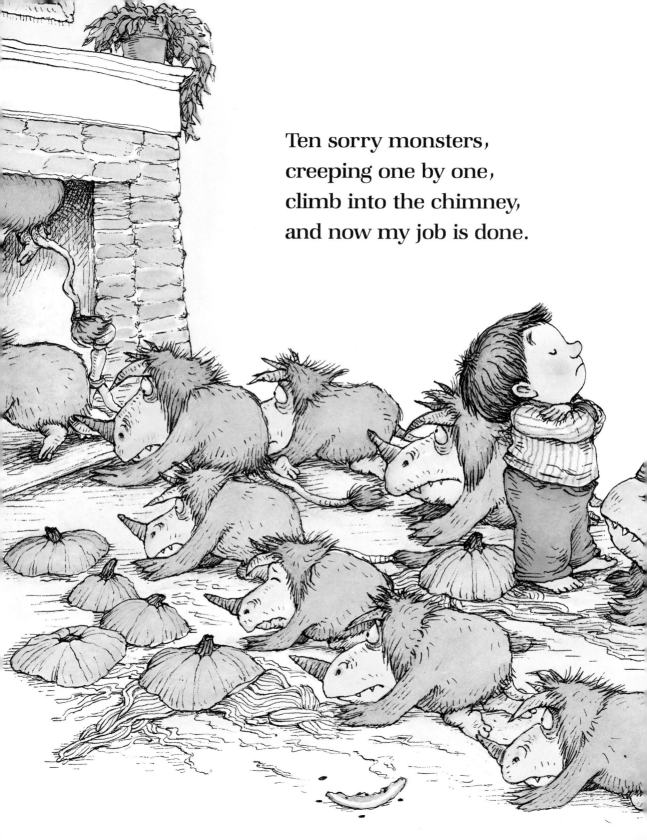

Ten sorry monsters,
creeping one by one,
climb into the chimney,
and now my job is done.

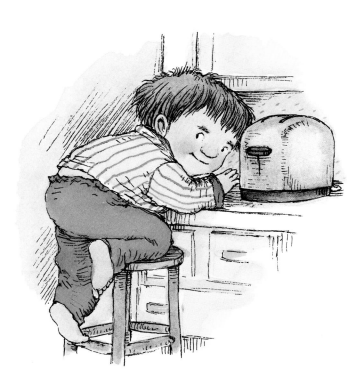

Then from behind the toaster,
my secret hiding spot,

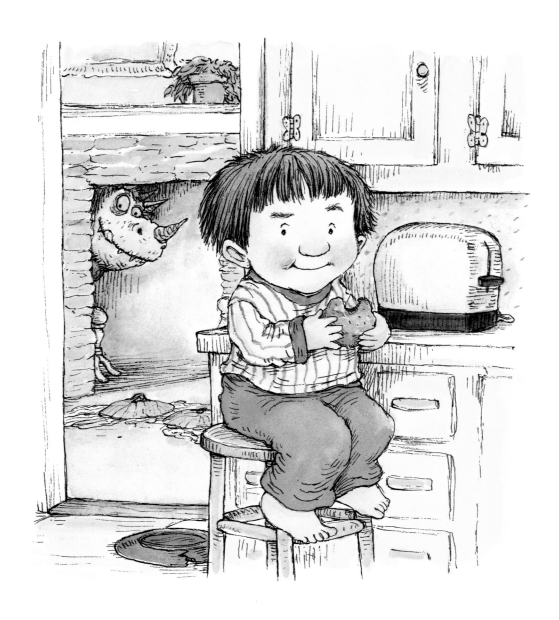

I take an apple muffin
the monsters never got!